Collins
30 minute
Watercolours

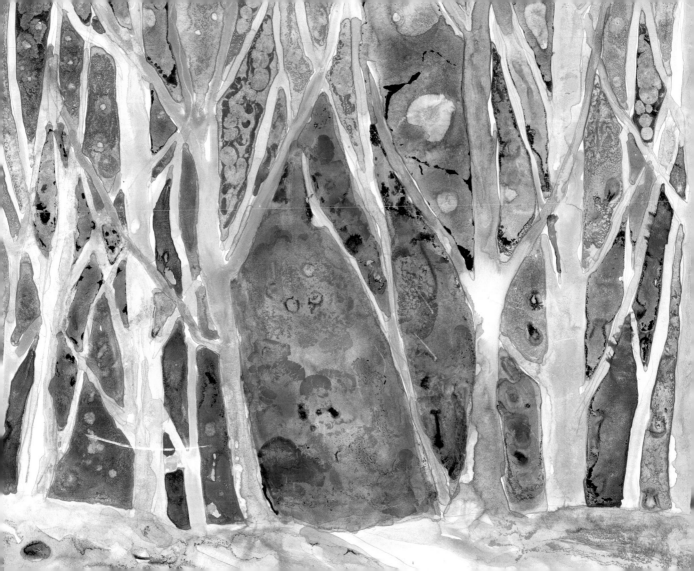

Watercolours

Fiona Peart

First published in 2007 by
Collins, an imprint of
HarperCollins*Publishers*
77-85 Fulham Palace Road
Hammersmith, London W6 8JB

www.collins.co.uk

Collins is a registered trademark of HarperCollins Publishers Limited.

12 11 10 09 08 07
8 7 6 5 4 3 2 1

Editor: Diana Vowles
Designer: Kathryn Gammon

ISBN 978 0 00 725649 5

Colour reproduction by Colourscan, Singapore
Printed and bound by Printing Express, Hong Kong

Page 2: **Winter Trees,** 20 × 26 cm (8 × 10 in)

About the Author

Fiona Peart is a professional artist and fully qualified art
tutor, specializing in watercolour and drawing techniques.
She runs popular workshops, gives talks and presentations
to various art groups, and also
demonstrates at art shows and
exhibitions throughout the UK.
She writes regularly for *The
Artist*, *Leisure Painter* and
StartArt magazines, as well as
contributing articles and
features to national magazines,
and has produced several DVDs
on watercolour and coloured
pencils. For more information,
visit www.fionapeart.com

Dedication
I would like to dedicate this book to my father, Bob Peart, who would have
been especially proud ... l inspired me, and my partner

CONTENTS

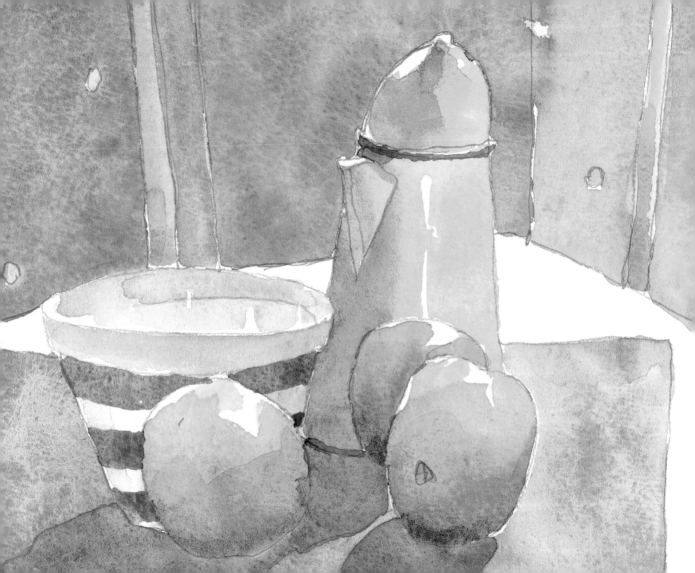

INTRODUCTION

For as long as I can remember, I have painted constantly. A picture may take me just a few minutes, or I may work on a more complex composition that can take days; one of the beauties of watercolour is that it is so adaptable to your circumstances and available time.

People often feel that they have to be able to set aside a lot of time to paint, but this really isn't the case. To encourage you to go ahead and pick up your paintbrush, my focus here is on a swift way of working to show you how to achieve successful paintings in just 30 minutes, using the minimum of equipment.

◀ **The Yellow Coffee Pot**
14 × 18 cm (5½ × 7 in)
Bright colours and a bold painting technique make this an exciting approach to a simple still life.

Keep it simple

One of the reasons that so many people find watercolour difficult is that they can't stop messing about with it! If you are a relative beginner or you haven't been painting for long, try to remember that the more time you spend on a painting, the more likely you are to overwork it and spoil it.

Allow the paint to move on the paper how it naturally wants to – don't try to force it to go where you want, because with watercolour the paint will always win. Instead, adapt the way in which you respond to the paint, depending on the way the pigments behave on the paper.

▶ **It Could Be the Fan Belt**
24 × 18 cm (9½ × 7 in)
This painting was done using the wet-in-wet technique. I lifted out highlights with a brush as the paint dried.

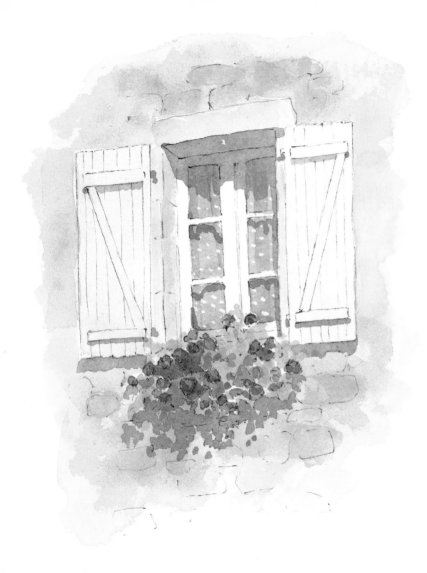

The aim of this book

Painting a picture doesn't mean you have to find hours of spare time to put aside – it's all about using the time you have available and considering the scale of picture you can realistically achieve as well as the most effective techniques to use. This can be just a matter of simple practicalities: a wet-in-wet start for a painting outdoors on a cool, damp day isn't advisable, but you could easily achieve that in 30 minutes indoors.

In this book you will find information focused on making the most of every minute, with quick exercises to set you on the right path. I hope it will encourage you to have a go and paint whenever you have the desire to, no matter how brief the time you have available.

◀ **French Shutters**
17 × 14 cm (6¾ × 5½ in)
To convey the heat of a sunny summer day in France I kept the colours quite bright and used a limited palette.

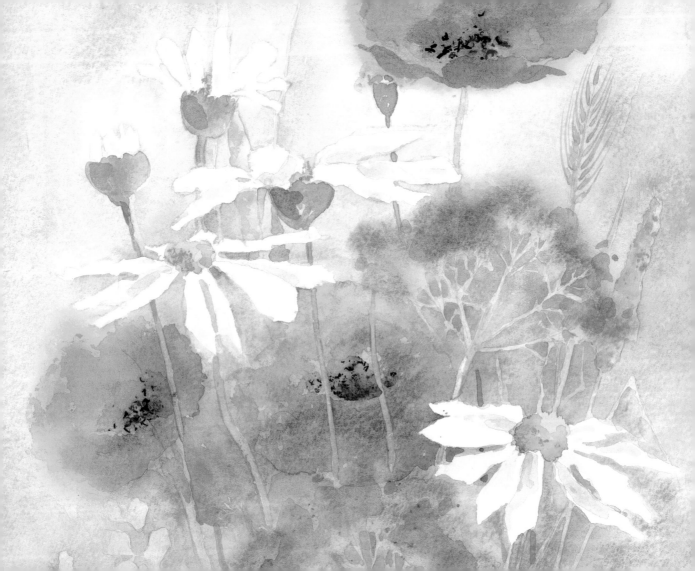

ESSENTIAL EQUIPMENT

What makes an artist is not sophisticated, expensive equipment, so you should not feel that you have to make a big outlay to create successful pictures. Using only minimal equipment will also help you to keep things simple and make the most of limited time.

You can buy paints in either pans or tubes. When you are using the latter, squirt the pigment into an empty pan so that you can easily dip into the colour. To avoid wasting time fiddling about with the tops of the tubes, make sure you have enough paint in your palette so that you can enjoy painting without interruption.

◄ **Garden Posy**
25× 35 cm (10 × 14 in)
Painting this on location, I improved on what was in front of me and added flowers from another part of the garden.

Paints

Paint comes in a variety of brands and types. Student colours are great for the beginner and are a cost-effective way of seeing whether you are going to enjoy watercolour painting before you spend more on artist's quality pigments. However, once you have decided you are serious about painting, artist's quality are the ones to buy for the best results.

Remember that while you can tone down colours, you can never make them brighter. Consequently, buying bright colours in the first place will give you the widest range to use in your paintings.

Paper

For small paintings, 380 gsm (200 lb) watercolour paper is ideal. Begin with an inexpensive paper such as Bockingford and stick to it until you feel confident – it's best to have as few variables as possible at first so that you quickly learn what your paints can do.

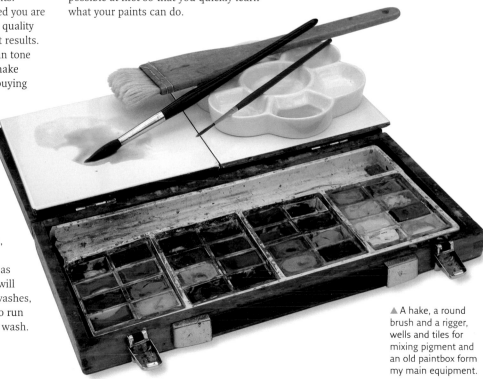

Palettes

Most paintboxes have their own palettes, but for mixing subtle colours the flat, smooth, porcelain surface of ordinary white kitchen tiles is excellent as you can see them clearly. You will need deeper wells for mixing washes, though, as it's important not to run out of paint halfway through a wash.

▲ A hake, a round brush and a rigger, wells and tiles for mixing pigment and an old paintbox form my main equipment.

Brushes

You don't need to buy a lot of brushes to start with, and in fact you can get by with just a No. 10 round brush. When you want to expand your kit you will probably find, like most people, that you basically need a fine, a medium and a wide brush to cover all the techniques you might want to use. All of the paintings in this book have been done using a No. 10 round sable brush, a No. 1 rigger brush or a 3 cm (1½ in) hake, sometimes in combination.

Other items

If you like to draw your subject before you begin painting, use a 2B pencil and a very soft putty eraser if you need to lighten or remove your lines. Press this against the surface to lift the lead rather than rubbing vigorously on the paper.

Accessories you will need include two big water pots if you're painting indoors, a big plastic bottle of water if you are painting on location, and some absorbent kitchen towel. Masking tape is useful for attaching the paper to the board as well as masking the area around a painting to create a clean edge. A hairdryer is handy to help you speed up the drying process where necessary.

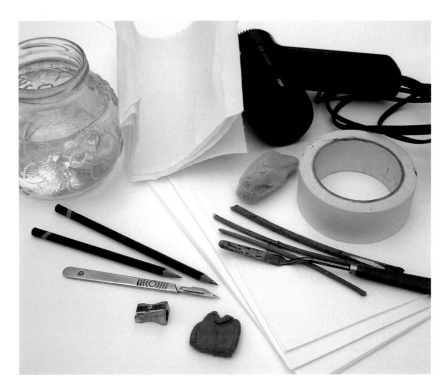

▲ Some of the items that you will find useful are already present in most homes, and sticks to draw with cost nothing at all.

BRUSH STROKES

A simple brush stroke is capable of describing a shape in an immediate and evocative way, interpreting the subject quickly and effectively. Grouped together, such brush strokes provide the means to develop a loose, painterly picture.

To avoid overworking your paintings, resist any temptation to fill in an area with too many brush strokes. Limiting yourself to a few individual strokes gives a crisper, cleaner result. Not only does it make for a better painting, it also helps you to work fast and produce lively work in just 30 minutes.

◄ **Leaning
Against Mother**
18.5 × 24 cm (7¼ × 9½ in)
I laid my initial
colours wet-in-wet.
As they dried I added
brush strokes in
the direction of the
animal fur.

Using the round brush

For applying wet pigment to dry paper, a No. 10 round sable brush is the most versatile tool to use. It has a big reservoir, allowing you to make long strokes without running out of paint, and retains its wonderful point.

The pressure line stroke

A simple brush stroke can be varied according to the amount of pressure that is applied when the loaded brush is in contact with the paper. Its shape can also be altered to suit the subject being painted – for example, curved lines are ideal for portraying leaves or flower petals, while straighter lines can show water very effectively.

Using a Hot Pressed paper with a smooth surface will produce a smoother drying line and a more fluid stroke.

▲ **Eucalyptus Leaves**
Here two pressure line brush strokes are grouped together, leaving a small gap to suggest a leaf vein. Variation was added to the leaf tones by dipping the brush into different greens.

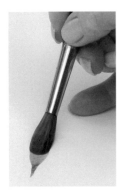

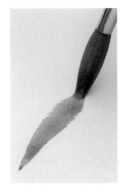

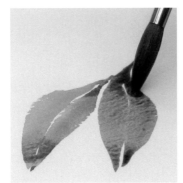

The quicker the stroke, the more fluid the line will look. A slow, tentative stroke will produce a wobbly leaf shape.

1 Mix two separate greens on a flat palette. Load the brush with darker green and dip the tip into the lighter green. Place the tip of the brush on to the paper then, moving in the direction of the leaf shape, press the brush down firmly.

2 Continue moving in the direction of the stalk and lift the brush to narrow the shape and create the leaf.

3 Repeat the process, leaving a small gap to suggest the leaf vein, then create a second leaf in the same way.

▲ Some leaves grouped together form the makings of a simple painting. Here the front leaves have been painted first and the other leaves slotted in behind.

The dry-brush stroke

Applied to a Not or Rough surface, the dry-brush stroke will skip over the tooth of the paper, leaving white showing to give texture and sparkle. It is an excellent technique for depicting water, giving the impression of waves and foam. It is also useful for textures such as stonework, gravel, sandy beaches and foliage.

You can also use the dry-brush stroke in a darker colour on top of a previous layer of paint once it has dried.

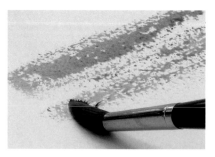

▲ Using the round brush dryer than with the pressure line stroke, drag its full length lightly across the surface.

▲ Using the brush on its side and dragging it in the direction the hair flows will apply more of the pigment to the paper.

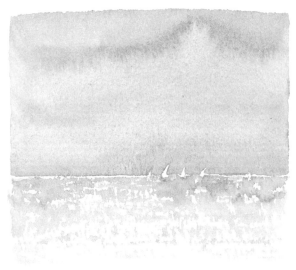

◀ **Sailing Boats**
After drawing the boats I laid a flat wash of French Ultramarine with the round brush, avoiding the white sails and stopping at the horizon. Then, using the same colour, I dragged a dry brush across the surface to create a sparkle on the water.

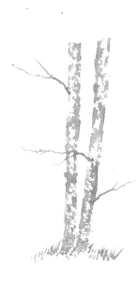

◀ **Birch Trees**
With my round brush, I dragged the paint from the outer edge of the tree trunk to the centre, all the way up. I added the twig and grass details with the rigger brush.

Washes

Laying a wash is the most basic technique of watercolour and one that you need to perfect to achieve successful paintings. One of the most important points to remember is to mix up sufficient paint to start with – if you have to pause to mix more your wash will potentially be ruined.

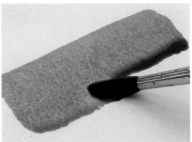

1 Keep the board tilted. Using a well-loaded brush, begin at the top and, using the point of the brush, drag the paint horizontally across the paper. A bead of paint will form if enough paint is applied. Continue to work down, adding sufficient paint to keep a bead.

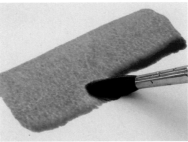

2 You can merge colours smoothly together by introducing an alternative colour into the wash.

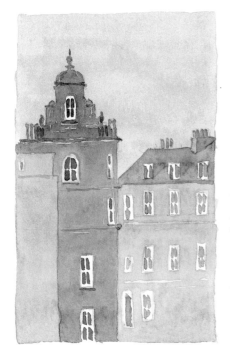

◀ **City Buildings**
14.5 × 9 cm (5¾ × 3½ in)
I laid a flat wash of Manganese Blue (Hue) over the entire picture, avoiding the windows. Once it was dry I laid a wash of Yellow Ochre over all of the buildings. I painted the rooftops and buildings using Winsor Violet and finally used a mix of all three colours to add the darker finishing details.

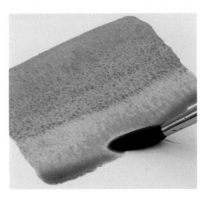

3 Continue to add more paint, retaining a bead in order to maintain an even, continuous wash.

Using a rigger brush

A rigger is a wonderful brush for textures, quick details and dropping in strong pigment in a controlled way. It was commonly used to paint the rigging on sailing boats before the age of steam, which is how it gained its name. Its calligraphic quality makes it equally suitable for branches and twigs.

Cadmium Scarlet

French Ultramarine

▶ **Winter Trees**
This group of trees was painted on Rough paper with a rigger brush. I used the dragging and lifting stroke and just two colours, Cadmium Scarlet and French Ultramarine.

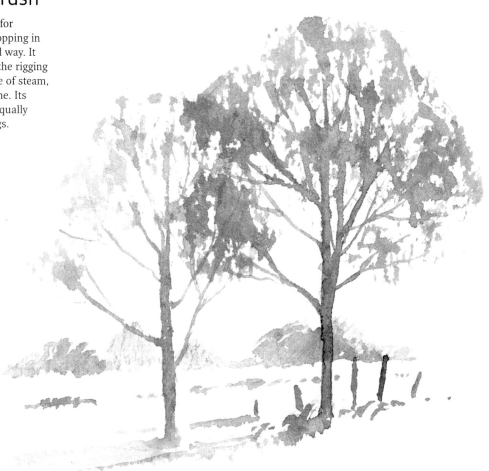

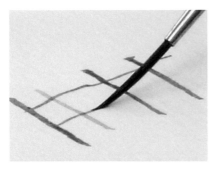

◄ The rigger brush holds such a large reservoir of paint that it is possible to produce a series of detailed shapes without having to dip into the paint continuously.

◄ A wonderful texture can be created by placing the full length of the rigger on Rough watercolour paper and dragging it across the surface.

◄ By laying the brush flat on the paper, dragging it downwards and then lifting it up to the tip, lovely shapes and textures can be created by the combination of strokes.

▼ I placed a loaded rigger flat on the paper at the top of the tree canopy and dragged it towards the trunk. I then released pressure so that only the point remained on the paper to paint the branches and trunk. I repeated this four times to build up the complete tree shape, then added the fence.

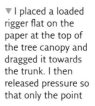

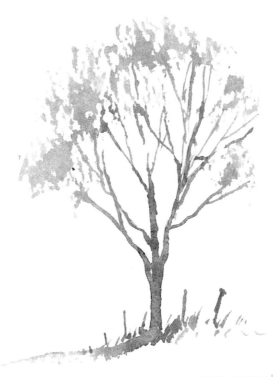

Using two colours

Using only two colours that can be mixed to the darkest tone you need, it is possible to achieve a small landscape in a very short time. Painting with a few simple brush strokes and not allowing yourself to get bogged down with details can result in a simple yet effective little watercolour.

MATERIALS USED
2B pencil
No. 1 rigger brush
No. 10 round brush
Saunders Waterford
 380 gsm (200 lb)
 Rough paper
French Ultramarine
Raw Sienna

1 Lightly draw the subject then, working flat, wet the paper with clean water, using the round brush. Drop in the light areas with Raw Sienna, add dilute French Ultramarine and let the paint seep naturally. Let this dry.

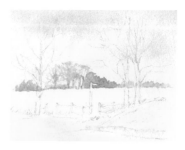

2 Mix a soft green and paint the tall distant trees with the rigger, using the dragging and lifting stroke. With the point of the round brush, put in the bushier trees. Drop in more pigment to the nearer trees.

3 Allow the paint to dry. Mix a darker, bluer colour and paint the nearer trees with the rigger, beginning with the canopy then working down the branches and trunks. Drop in more blue wet-in-wet to darken the tones.

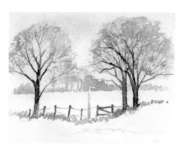

4 Work on the nearest tree, darkening the tones to make it advance. Using the rigger and Raw Sienna, paint the signpost, then add blue to the mix and paint the fence. With the round brush, loosely paint the grasses.

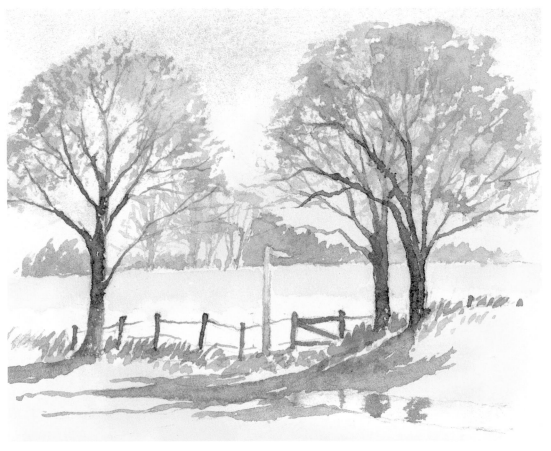

◄ Summer Trees
13 × 15 cm (5 × 6 in)

5 With the round brush, use a blue mix with just a hint of yellow to tone it down and add the shadows, avoiding the puddle area.

Finally, using clean water, dampen the puddle and add the reflections in a slightly darker colour with the rigger.

Using the hake brush

A hake brush is mainly useful for wetting the paper for wet-in-wet techniques or creating textures. Made of goat's hair, hakes have the advantage of soaking up liquid and applying it evenly. This means that when you apply clean water the surface will be uniformly wet, making it easier to judge the drying time as you paint, and where you use a hake for laying a wash of colour it will dry evenly.

▶ **Two Blossom Trees**
The texture of the blossom and foliage was created with a hake brush, giving a loose, suggestive style to the painting.

▶ Dampen the brush and splay it out against your palm. Dip the tip into the paint then hold the brush vertically and press it gently and repeatedly against the paper in a stippling movement to create small blobs of colour.

◀ You can create loose linear effects by loading the brush in the same way but applying the paint with a firm flicking action so that a series of lines is created. The curve can be altered by the direction of the stroke.

◀ For a different linear effect, dip the brush into the water and gently squeeze out the excess. Dip the tip into the paint and touch the paper with the length of the tip, creating a straight line. Repeat this stroke to achieve dramatic textures.

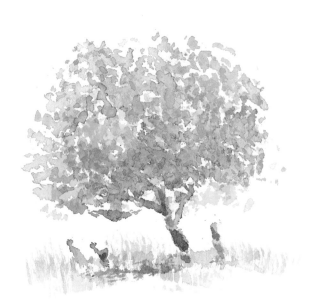

◀ This quick tree study was created by applying Permanent Rose and Country Olive using a combination of the brush strokes shown above.

QUICK OVERVIEW

☐ When you place a brush stroke on a dry surface a descriptive shape with hard edges will be created.

☐ In the case of a brush stroke on a wet surface the emphasis is on changing or merging colour rather than shape.

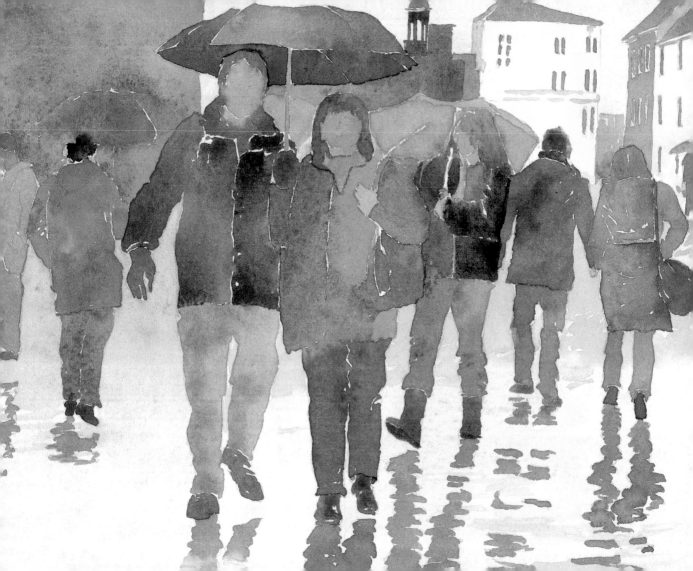

KEY TECHNIQUES

Stunning effects can be created in watercolour with very few techniques. Used simply and quickly, these can often result in wonderfully succinct watercolours that are more effective than those that have been laboured over for too long. I'm a great believer in getting the paint on the paper and letting its qualities work for me rather than fiddling around with it too much.

In simple terms, there are only two ways for the artist to use watercolour pigments: laying paint on a dry surface (known as wet-on-dry) or a wet one (wet-in-wet).

◀ **April Showers**
19 × 24 cm (7½ × 9½ cm)
Letting the paint run between the figures in this busy scene helped to link them together and create a tight composition.

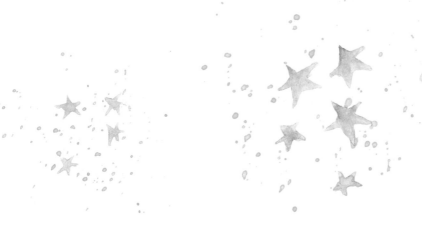

◀ Again Cadmium Yellow was flicked on to the paper, then applied with the point of the round brush to create larger star shapes. Permanent Rose was then dropped in while the yellow was wet (see pp.30–31).

▲ Cadmium Yellow was flicked on to the paper by tapping the brush against my hand to create the tiny blobs of colour suggesting distant stars. The point of the round brush was used to define the larger, angular stars.

Wet-on-dry

Applying wet pigment to a dry surface will create hard edges which will define each shape, whether you are painting small, medium or large areas. If you want to avoid this edge you will need to work dryer. This means applying less liquid to the paper, either by loading a smaller amount of paint on to the brush in the first place or by covering more of the paper before reloading it.

◀ This area of French Ultramarine was applied with the round brush, avoiding the small areas and shapes. Note the drying line around the shape. This is always far more noticeable when you are using a darker colour.

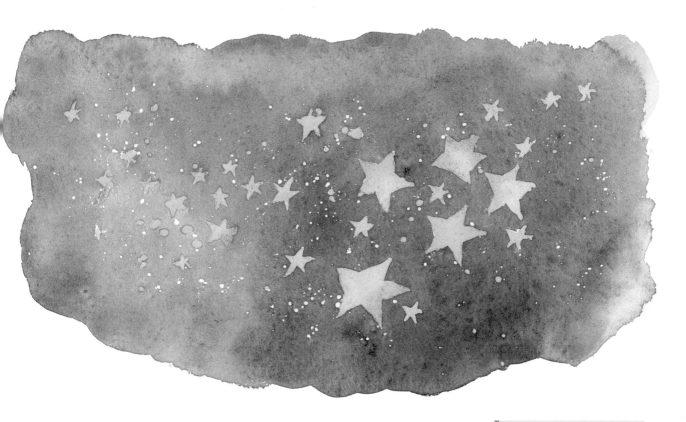

▲ Milky Way
By employing a combination of these shapes, a simple little watercolour study can be created. Using French Ultramarine for the sky area gives an intense colour, enhanced by adding Permanent Rose to the mix to create a hint of purple.

To avoid the paint running into adjoining sections, make sure that the surface of the first shape is totally dry before you add the next one.

Wet-in-wet

By adding a second layer of paint into the first while this is still wet, you can create a diffuse effect. If you use just one colour you can change its intensity and tonal values by altering the ratio of water to pigment, while dropping in different colours will give you softly merged shapes that will suggest subjects within a painting. Pushing the colours about will lead to a muddy mix, so let them merge naturally to achieve a luminous result.

◄ Create the initial shape by laying a wet wash of Raw Sienna on to dry paper, then drop in Cobalt Blue and Cadmium Scarlet and let the colours merge naturally.

Cadmium Scarlet

Raw Sienna

Cobalt Blue

◄ Working in the same way as in the smaller area, merge the colours on a larger scale. The yellow drying line around the outside of the shape will be created by the added colours pushing the Raw Sienna outward. The initial colour will always create the drying line, so you can control which colour this will be.

◀ Although the shape is larger, this sky can be created in exactly the same way. Lay a wash of Raw Sienna, then drop in Cobalt Blue and let the pigment merge naturally; this gives a wonderful luminosity to the sky without mixing a green. While the area is still wet, mix a little Cadmium Scarlet with the blue and add this to the underside of the clouds to suggest a soft, billowy sky.

Wet-in-wet skies

Laying an initial wash of Raw Sienna will give an overall warmth to the sky, while wetting the paper with clean water then dropping in the blue will give a more appropriate effect for cooler landscapes. A good way to imply lacy edges to the clouds is to form a soft pad with a piece of kitchen towel and gently dab the cloud edges to lift the water.

QUICK TIP

When you are applying the blue, you will need to leave areas of white paper for the clouds. Remember that on wet paper the blue will spread into the white areas, so leave plenty of room to allow for this to happen.

Working on wet paper

One of the wonderful aspects of watercolour is the way in which it responds to water. Pigments have different qualities: some rush across the wet surface, while others seep gently away from their origin.

A painting done on wet paper in one stage can be very exciting, but it does involve reacting to the way the paint runs on the surface. By tilting the paper you can encourage the paint to move in the direction you want it to go so that you have more control. As long as the surface remains wet you can continue to drop paint onto it, creating some dramatic colour merges.

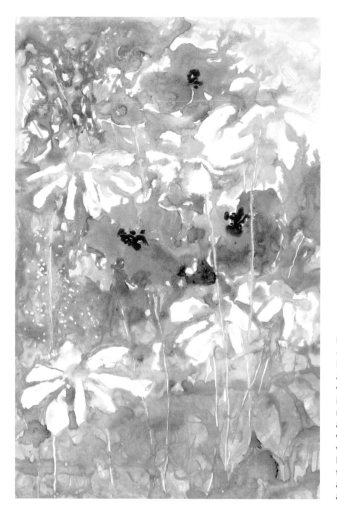

◄ **Poppies and Daisies**
40 × 27 cm (15¾ × 10½ in)
I wetted the paper all over with clean water then dropped in my colours. With my thumb, I pushed away the water where I wanted the white daisy petals. I used my thumbnail to move the paint and depict stalks and spots.

◀ Pigment can be accurately placed onto a wet surface using either a rigger or a round brush. The wetter the paper the more the paint will run.

▼ The pigment can also be flicked or spattered on without touching the paper at all, creating some wonderful speckled textures. Load the rigger and firmly tap the brush to release the pigment.

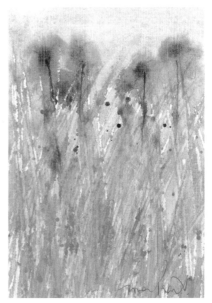

◀ **Poppies**
20 × 8 cm (8 × 3¼ in)
Using clean water, I wetted the paper then dropped in red for the poppies. I waited to see how the paint moved and dropped in a little more. Next I drew in the stalks and leaf shapes and added the dark centres.

▶ **A Field of Poppies**
14 × 10 cm (5½ × 4 in)
After wetting the paper I washed in the blue sky then flicked and splashed paint onto the surface. I moved the paint with my fingernail to suggest stalks. I continued to flick the paint as the paper was drying.

Working on wet shapes

Instead of working wet-in-wet over the whole area, you can apply water to smaller sections, creating wet-in-wet within particular shapes. If the colours are to be separate each shape must be dry before the adjoining one can be painted or a tiny gap must be left to prevent the colours running.

Shadow

Raw Sienna

Permanent Rose

▶ **Curious Cows**
I wetted the shape of the cows and dropped in dilute Raw Sienna. While this was still wet I added Shadow to the knees and hoofs. With a mix of Permanent Rose and Raw Sienna I created the warmer sections of the body. When this had dried I put in the pink noses.

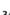

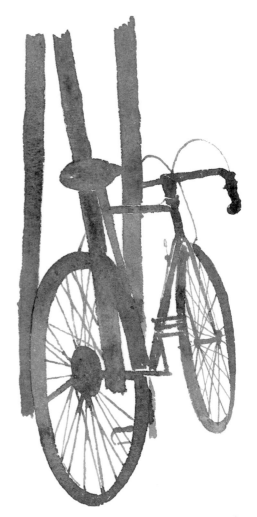

▶ Welcome Break
The silhouette of this bike was a perfect subject to tackle in a simple wet-in-wet way. I wetted the shape and began dropping in all the colours I could see – it didn't matter if the posts merged into the bike in places, although I tried to keep the shapes separate with my use of colour rather than with a lot of spaces.

◀ Water Pump
I painted this water pump in one stage, dropping in various colours, watching how they merged together then dropping in more. Where I didn't want sections to merge I left a small dry gap to separate them. I worked on it until it dried, adding the final dark details at the end.

◀ **Campanulas and Pink Daisy**
30 × 17 cm (11¾ × 6¾ in)
Each section in this painting was created as a wet shape, with colours allowed to merge within it.

Wet-in-wet within shapes

Creating a picture using the wet-in-wet within shapes technique will improve your understanding of paint movement and colour density. A good subject would be a spray of simple flowers or a still life of a watering can and terracotta pots.

Build up a painting
Draw an outline on 380 gsm (200 lb) Hot Pressed or Not watercolour paper. Using your round brush and choosing any suitable very dilute base colour, begin with a foreground shape. Next, with your rigger, drop in various colours as you see them. Continue to drop in pigment as the shape is drying to create darker sections within the same shape.

Build up your painting by adding the shapes behind this first one – but take care that the first shape is dry or the colours will run into each other.

Once you have begun to feel confident working with this method of painting, try creating a landscape by using wet-in-wet within shapes all over the paper. Drop in the background colours then, as the paint dries, add stronger pigments to distant trees or hills. Once these are dry, paint the foreground with wet-in-wet shapes.

Points to remember
- Tackle each complete shape individually, dropping in different colours while it's still wet.
- Let the first shape dry to avoid the colour running into any adjoining shapes you paint.
- If the shape has a descriptive drying line around it, you have worked at the right consistency. If it hasn't, this usually means you have worked too dry.
- Use a well-loaded round brush with a good point to create each individual shape.
- Use a rigger to drop in colours.

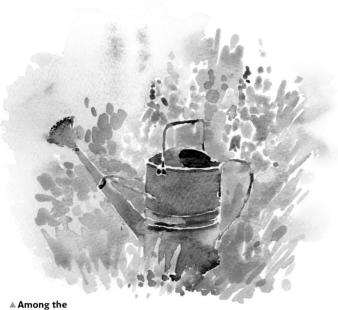

▲ Among the Bluebells
17 × 20 cm (6½ × 8 in)
After laying paint wet-in-wet over the background area I added wet-in-wet shapes once it was dry to give depth to the painting.

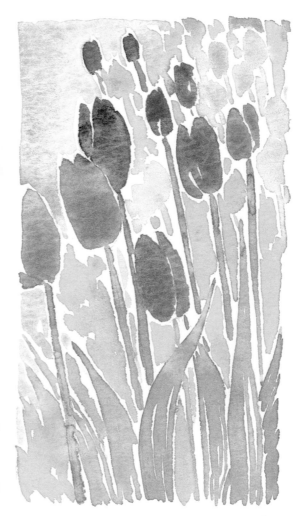

▶ Spring Tulips
15 × 9 cm (6 × 3½ in)
I began with the shapes of the flowers then positioned the leaves and stalks around them. All of the shapes were still wet as I finally added the sky area.

Other techniques

A brush is the first tool that most people think of as a means of laying paint on paper, but using a range of implements to handle paint allows you to create different effects that will enliven your work. If you have only a short time to paint and you cannot decide what to do, developing different techniques like these is always time well spent as you will know how to use them in a subsequent painting. Discovering how the paint reacts on the paper and how you can move it about is very useful and can result in some real surprises.

Sponges
Using a sponge is a very good way of suggesting texture, especially for such things as foliage or stone. Different types of sponges will give alternative textures; a natural sponge tends to give a finer, more random texture than a synthetic one. The wetter the sponge, the larger the blobs of colour, so by varying this combination a huge array of possibilities can be developed.

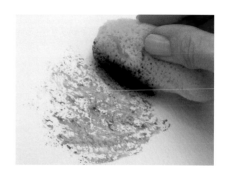

A palette knife
A palette knife makes a good tool for flicking paint onto the paper. Use either the end of your finger or your nail, pull the blade back and release to flick the pigment. The closer you hold the knife to the surface the more you will be able to control the area of paint spattered. The wetter the paint, the larger the speckles will be. Whether the paper is dry, damp or wet will also affect the finished results.

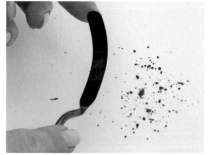

A stick
A stick from the garden creates some natural effects not possible with a brush. The quality of your line will depend on how the stick is snapped or torn. Dipping the stick into a well of paint so that it is well loaded and adjusting the intensity of the pigment will dramatically affect the end result.

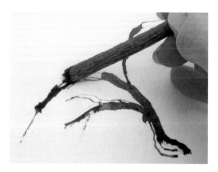

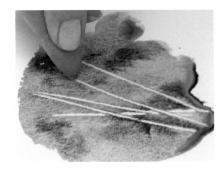

Your fingernail

Applying a firm pressure on the surface of wet paint with the back of your nail can push the pigment, leaving the paper surface exposed. This has the advantage of creating light lines, often thought difficult to achieve in watercolour.

◄ **Flower Field**
I applied the blue sky with a sponge on wet paper. I flicked on splashes and spots of colour with a palette knife and used my nail to reveal white lines. The flower stems were painted with a stick.

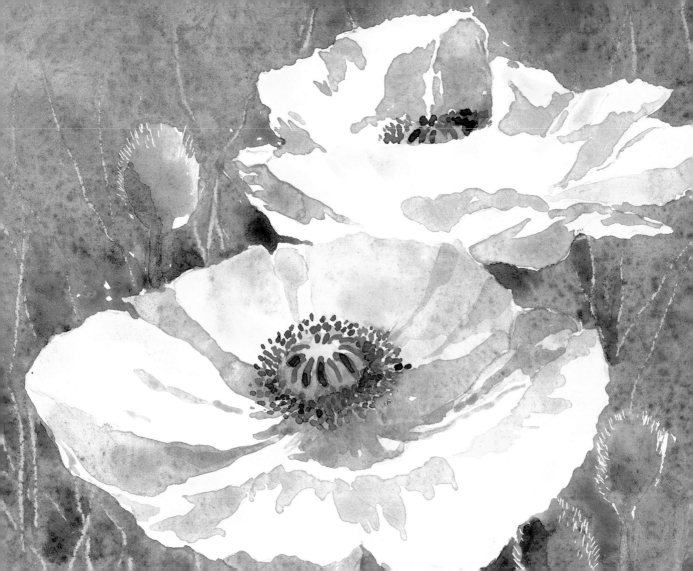

USING COLOUR

Colour has an effect upon us all; it can change our mood, uplifting us, making us contemplative or lowering our spirits. The way in which you use colour in your paintings will initiate a response from the viewer, so by emphasizing certain colours you can considerably influence the effect your painting will have.

Using vibrant colours doesn't necessarily mean that your work will be bright; by mixing the right colour combinations you will be able to achieve some very subtle, moody paintings as well. You don't need to use a wide range of pigments, and restricting yourself to a limited palette will make it easier to paint a picture in just 30 minutes.

◀ **Icelandic Poppy**
17 × 22 cm (7 × 8½ in)
In reality, these flowers were pink and the foliage was green; I moved all their colours round the colour wheel.

Complementary colours

Complementary colours are those colours that sit opposite each other on the colour wheel – for example blue and orange, purple and yellow, red and green.

Complementaries can produce colours ranging from the brightest mix to intense greys and neutrals. Choosing the right complementaries is the key to success. It is often advisable to choose bright colours for mixes as you can always tone a colour down but you cannot brighten it. If you choose more subdued colours it is best to avoid dull mixes by letting the colours blend naturally on the paper.

A two-colour palette

Using just two colours to paint a picture can unify the subject and create impact quickly. By limiting your palette in this way you will spend less time thinking about mixing colours and more time actually painting.

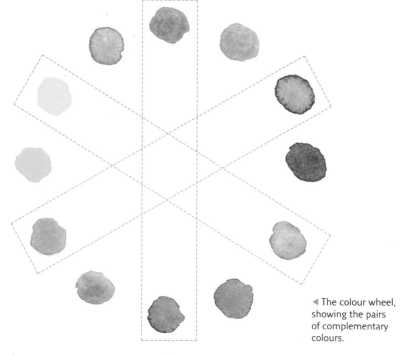

◄ The colour wheel, showing the pairs of complementary colours.

▲ Subdued complementaries: French Ultramarine and Raw Sienna.

▲ Bright complementaries: Manganese Blue and Scarlet Lake.

◀ **Mahon Fort**
14.5 × 9.5 cm
(5¾ × 3¾ in)
In this painting
I used Manganese
Blue and Scarlet Lake
either individually
or mixed together in
various strengths
to achieve a very
natural result. It was
painted on location
on a very hot day
in Menorca.

■ **QUICK TIP**

Mixing the colours on a flat
white surface such as a white
kitchen tile will help you see
subtle changes.

▲ Manganese Blue
and Scarlet Lake (an
orange red) mixed
together produce a
range of neutrals.

Enhancing colour

Paintings can become so much more
exciting if colours are emphasized,
exaggerated or even changed altogether.
It is surprising how a subject remains
logical despite altered colour; provided
the colour and tonal balance remain
correct you can paint red trees, blue grass
and green flowers and your paintings
will still work.

◀ **Dome Against
the Sky**
16 × 13 cm (6¼ × 5 in)
The day was rather
grey and overcast.
Using just two
complementaries,
Permanent Rose
and Emerald Green,
resulted in a far more
interesting picture
than if I had painted
exactly what I saw in
more muted colours.

◀ **Reed Beds**
15 × 9 cm (6 × 3½ in)
I used Manganese
Blue and Cadmium
Scarlet to create an
impressionistic view
of this windmill. In
reality there was far
more green and
yellow in the scene,
but it was the linear
patterns rather than
the colours that most
interested me.

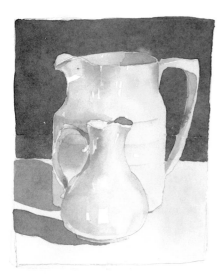

▲ **Milk or Cream?**
17 × 14 cm (7 × 5½ in)
These two jugs on a white cloth are obviously white, but there is no white paper showing. The subtle colours suggest form and luminosity, giving a more exciting result to what could be a very ordinary subject.

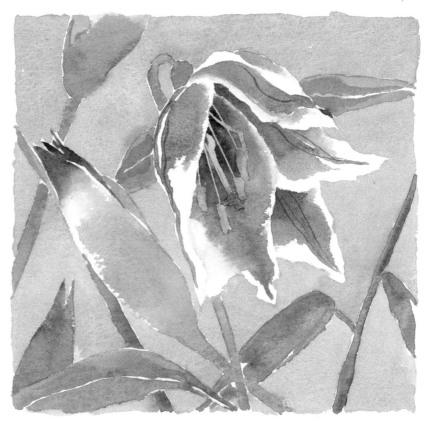

▶ **Purple Lily**
16 × 17 cm (6¼ × 7 in)
Here the colours have been changed dramatically to create an unusual painting. Despite the colours being different from reality, the picture looks right because the tonal values and colour balance remain correct.

Using warm and cool colours

Put simply, the colours on the green and blue side of the colour wheel are cool and those on the red and yellow side are warm. However, within those divisions there are cool reds, warm blues and so on.

You can use warm or cool colours to emphasize the mood in a painting, or change it completely. Snow scenes, for example, can be very cold-looking paintings, but by using warm colours a totally different mood is suggested.

Warm colours

Cadmium Yellow + a touch of Winsor Blue (Green Shade) = cool yellow

Cooled

◀ To cool a warm colour, add a little pigment from a colour on the cold side of the colour wheel.

Cadmium Yellow Deep + a touch of Winsor Blue (Green Shade) = cool orange

Permanent Rose + a touch of Winsor Blue (Green Shade) = cool pink

Cool colours

Winsor Blue (Green Shade) + a touch of Permanent Rose = warm blue

Warmed

◀ To warm a cool colour, add a little pigment from a colour on the warm side of the colour wheel.

Cobalt Blue + a touch of Permanent Rose = warm blue

Winsor Violet + a touch of Permanent Rose = warm purple

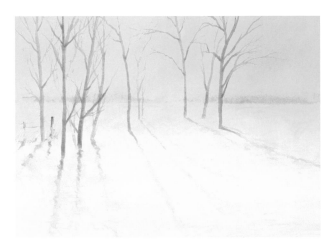

◄ Winter Walk
21.5 × 30 cm (8½ × 12 in)
This was painted from sketches done on location. I used complementaries for impact and changed the entire mood of the painting by using warm colours. The sky wasn't really that colour, nor were the trees blue of course, but changing the colours made a more exciting painting from a relatively ordinary subject.

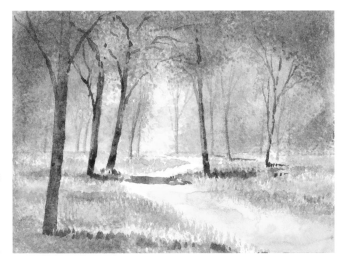

► Spring Walk
20 × 25 cm (8 × 10 in)
In this warm and sunny spring bluebell walk I emphasized the coolness under the foliage canopy.

QUICK OVERVIEW

☐ Check that your complementary colours sit opposite each other on the colour wheel.

☐ Use bright pigments if you are going to mix them.

☐ If you choose more subdued colours, avoid mixing them in the palette to prevent dull mixes.

☐ Use a flat mixing surface for subtle colour changes.

☐ Keep the correct tonal balance even if you change the colours.

Using colour for mood

For this painting I used mainly watercolour washes, allowing the pigments to seep into the paper surface and stain it, giving luminous results. In this famous view of Venice, it's the shapes of the distant buildings, the foreground boats and the long posts that make it an ideal subject.

MATERIALS USED
2B pencil
No. 1 rigger brush
No. 10 round brush
Bockingford 535 gsm
(250 lb) Not paper
French Ultramarine
Raw Sienna

1 Begin by mixing two wells of colour for the underpainting that will set the mood of the picture as well as the starting tonal value. Using the round brush, apply a graded wash, letting the blue merge into the yellow then the yellow merge back into the blue.

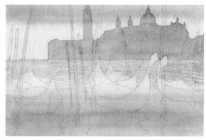

2 Let that dry then, using the blue, wash over the distant buildings; it will appear bluer over the blue and a cooler grey-blue over the yellow. Using your round brush and the same colour, apply short horizontal strokes on the water to create reflections.

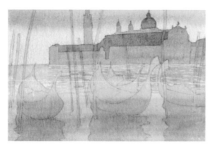

3 Once that is dry apply another wash, this time adding a little of the yellow to the blue mix for the dome to give the impression of light hitting it. Use pure blue for the roof, which is in shadow and therefore cool, and pure yellow for the roof on the right.

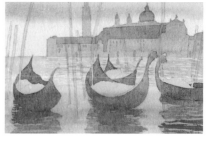

4 Using the rigger and pure blue, add some windows and doorways. With the round brush, mix a slightly deeper blue and apply it to the boats and their reflections, treating each boat and its reflection as one shape rather than two objects.

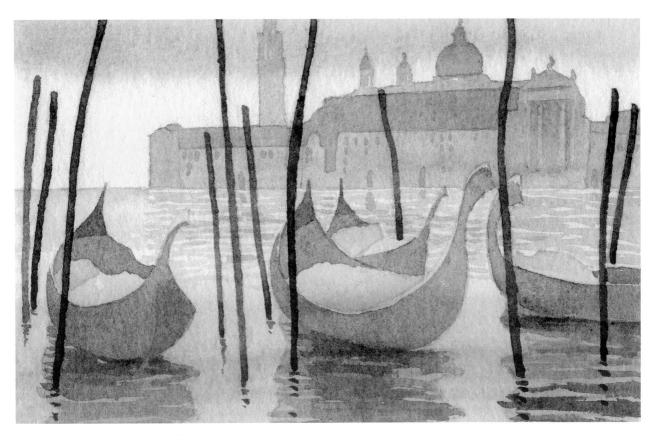

5 Add more details to the distant buildings. With the deep blue, paint shadows on the back of the boats and darken the water beneath them. With the round brush, mix the darkest colour you can by adding just enough yellow to change the blue into a blue/grey. Keep the colour as wet as possible without losing its depth and put in the posts. While they are still wet, drop in some intense Raw Sienna at the top, using your rigger.

▲ **Venetian Gondolas**
13 × 20 cm (5 × 8 in)

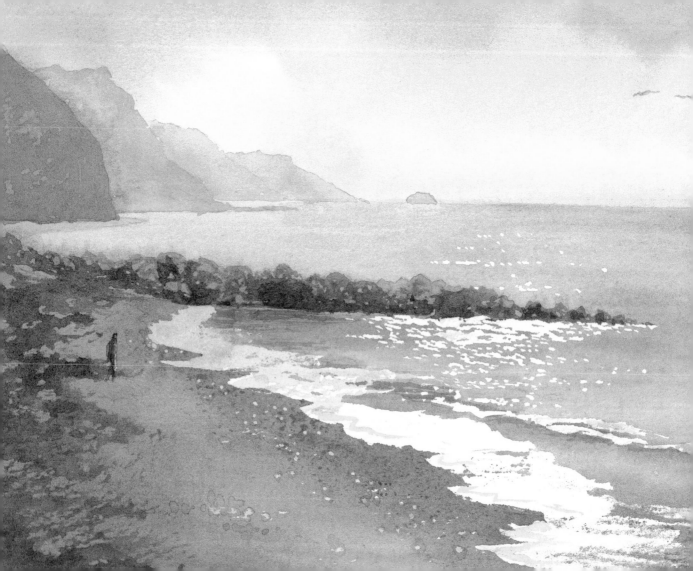

EMPHASIZING TONE

Getting the tonal balance right in a painting results in a more successful composition. You can emphasize the tonal balance by limiting the number of tones you use, which has the effect of not only simplifying your subject but also creating real impact. This approach is ideally suited to achieving a picture in 30 minutes, too.

I find that I am naturally drawn to subjects with strong tonal contrasts and interesting shapes. I like to suggest that within the dark areas there is interest but the details remain for the viewer to complete; that way something is left to the imagination, giving the potential for everyone to see something different within a picture.

◀ **Evening Walk**
18.5 × 24 cm
(7¼ × 9½ in)
Leaving the highlights on the water as white paper, I mixed strong darks to create the illusion of evening light.

What is tone?

'Tone' refers to how light or how dark something appears. If you think of your subject as if it were a black and white image with a complete absence of colour, only tone remains to define it.

The range of tonal gradations in a subject may be huge, but you can simplify them down to a small number. This has the advantage of forcing you to look closely at your subject and concentrate on tonal blocks rather than fiddly little details.

QUICK TIP

Don't be tempted to slot in another tone to make six. It will be far more difficult to paint.

▲ **Tonal Study**
This tonal study shows the simplified way in which I paint my tones. The sea has four tones: tone 1 where the paper is untouched; tone 2, the lightest area of water other than paper; tone 3, the darker mass of water; and tone 4 mainly on the horizon line and deeper water.

1 2 3 4 5

▲ The five tones I use range from white paper to almost black. It's very dramatic but works for me.

Deciding upon tone

When you are searching for tones, it is often easier to half-close your eyes so that you are only just looking through your eyelashes at the subject. This prevents you from focusing on detail and forces you to look at how light or how dark areas of the subject appear to be.

Limiting yourself to five tones means that decisions have to be made about which category to put a tone in, so even if you can see more than five tones you will need to group them together – a tone between two and three will need to go into one or the other, for example. This will make the painting process simpler.

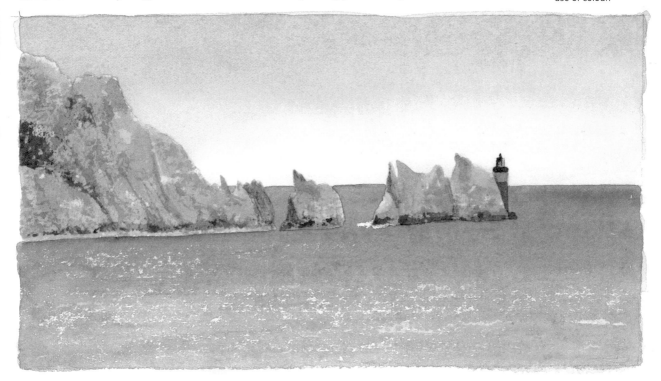

Analysing tone

The aim is to create a small painting by analysing five tones then using just two colours to paint it. This will improve your understanding of tonal values and demonstrate the importance of how the correct tone affects your final painting.

Looking for tones

The subject for this project can be anything you like, but to make it easy for you to practise your handling of tone it's best initially to choose simple shapes such as a group of trees or a distant landscape. Decide how much of the subject you are going to include and make a simple outline drawing on your watercolour paper.

▲ **Summer Shade**
10 × 10 cm (4 × 4 in)
This little view from the window of a country house was cropped naturally by the window frame. I made a tonal sketch, which I adapted later.

Now, spend a little time looking at your subject through half-closed eyes and judging the tones. It is much easier to decide first which areas are to be left white paper (tone 1). Next, look for the darkest areas (tone 5). After this it becomes easier to find the middle tone (tone 3). Once this is established you can slot the other two tones into place.

Once you have decided on your tones you need to choose your colours; think of their capability for rendering the darkest tone and the mood of the subject. Use complementaries for impact.

Mix a large well of the darkest tone, then put some of this into another well and add some water to it. Repeat this process until you have four wells of varying tones from tone 5 to tone 2 (tone 1 is white paper). Using your round brush, paint your subject from the lightest tone to the darkest.

Points to remember
- Plan your picture before putting any paint on the paper.
- Make sure you limit yourself to just five tones.
- Mix your darkest tone first so that you know you are able to mix a dark enough colour with the pigments you have chosen.
- Remember that your white paper functions as tone 1.

French Ultramarine Burnt Sienna

◄ **House in the Woods**
18 × 10 cm (7 × 4 in)
I made a tonal study of this house in my sketchbook on location. This gave me the information from which to make a tonal painting later.

◀ **Weekend Regatta**
27 × 37 cm
(10½ × 14½ in)
This painting was
begun with a graded
wash, avoiding the
tiny sailboats. Then
I used traditional
washes, starting from
the back of the
painting and working
forward, finishing
with my darkest
tone. Avoiding details
and painting only
what is necessary
is an excellent
technique for
working outdoors.

Mixing dark tones

Colour is only as dark as the pigment you use – if you just add more pigment, a denser colour results, not a darker one. In other words, if you choose a blue and an orange to mix your dark you need to choose two strong colours, preferably transparent, to do this.

Naturally dark colours such as Indigo work successfully with colours such as Burnt Sienna. Reducing the amount of Indigo in the mix will give you lovely warm areas in the lighter tones of a painting. Permanent Rose and Winsor Green (Blue Shade) make wonderful darks and either of them will create beautiful lighter tones, too.

▶ By mixing Cerulean and Cadmium Scarlet together a dull, muddy dark is produced.

▶ A transparent blue such as Winsor Blue (Green Shade) mixed with the same Cadmium Scarlet achieves a different, transparent dark.

QUICK OVERVIEW

☐ Simplify your subject into five tones.

☐ Make sure you can mix the darkest tone with the colours you have chosen to paint your picture.

☐ Check you are able to mix strong transparent darks.

☐ Keep the colours pale to begin with and avoid losing your lightest tone.

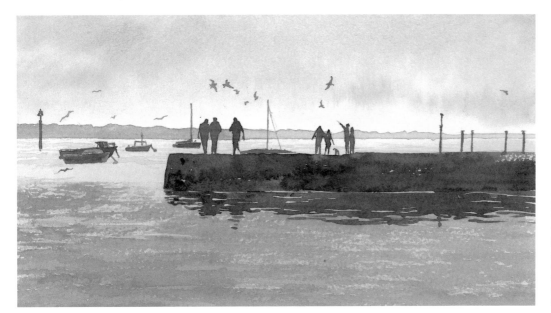

◀ **Last Walk Before Dusk**
15 × 27 cm (6 × 10½ in)
This was painted late one autumn afternoon. The warm evening light contrasts strongly with the cool dark tones of the jetty.

Tonal contrasts

Using strong tonal contrasts can result in very dramatic paintings which emphasize light. In order to create this quality of light in a painting it is vital to paint strong darks. However, where there are large expanses of dark you need to remember to make the tones varied and interesting.

MATERIALS USED
2B pencil
No. 1 rigger brush
No. 10 round brush
Saunders Waterford
 380 gsm (200 lb)
 Rough paper
French Ultramarine
Permanent Rose
Raw Sienna

1 Lightly draw the subject. Working flat, wet the paper with clean water using the round brush, leaving some tiny sections and an area at the foot of the cliffs dry. Drop yellow into the light areas then add a dilute mix of the blue and add this to the sky and sea, letting the paint seep naturally. Add a little pink to the blue mix and block in the foreground cliff, dropping some yellow into the rock sections near the water's edge. Let this dry.

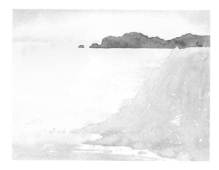

3 Once this has dried, build up the sparkle on the water by using the same colour as you used for the hills and dragging the paint across the surface with the round brush (see p.18). Build it up gradually until you have the contrast you want, then let this dry. It is important that the colour is deep enough to create a strong tonal contrast otherwise the impact will be lost.

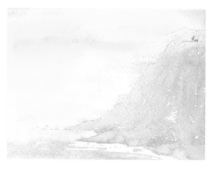

2 Create the light on the water by painting a very dilute wash of blue up to the horizon. Blend a stronger, more purple colour by mixing the blue with a little of the pink. Using the round brush, paint in the distant land mass, and while this is still wet drop in a little of the yellow on top of the hill with the rigger to give the impression that the sun is just catching the ridge.

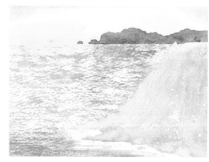

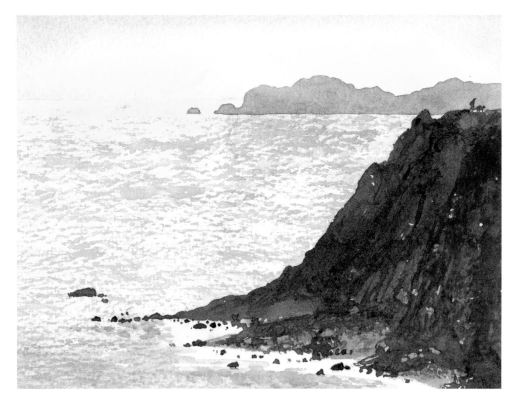

4 Using a darker mix of the blue and pink and the round brush, quickly block in the foreground cliff. Paint the edge with the point to get a sharp edge and fill in the remaining mass using the brush on its side. Merge a mixture of the yellow and the pink into the beach and rock area by the water's edge. Mix a very dark blue using all three colours and, as the base starts to dry, use the rigger brush on its side to create the rock textures. Use the point of the rigger in the direction of the rock falls to suggest the land contours. Finally, add a few rocks in the shallows and on the beach area.

DIRECT PAINTING

There are few ways of painting quite so exciting as starting with a blank sheet of paper, loading up a brush and deciding where to place that first small shape of colour. Painting directly on to the paper without drawing your composition first avoids the tendency to include details and is a wonderful way of creating dramatic watercolours with impact.

The phrase 'less is more' sums up the advantage of painting in this way and it is a method I recommend, even for an absolute beginner painting in watercolour. Direct painting will also make it easy to produce a pleasing picture in 30 minutes or less.

◀ **Monday**
19 × 25 cm (7½ × 10 in)
Using bright colours and keeping them fresh and clean gave an immediacy to this picture of washing blowing in the wind.

What is direct painting?

In direct painting, no drawing is done; the paint is applied straight on to the dry, flat paper so wet that it stains the paper as it dries, producing a luminous effect with a descriptive drying line around each shape. Spaces are left between the various shapes to avoid the paint running, though it is allowed to run in places to give a more painterly effect. This also has the advantage of linking some sections together. In fact, entire paintings can be created with just one shape.

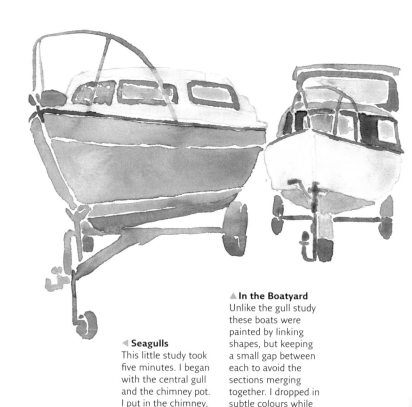

▲ **In the Boatyard**
Unlike the gull study these boats were painted by linking shapes, but keeping a small gap between each to avoid the sections merging together. I dropped in subtle colours while the hulls were still wet to add form to the boats.

◄ **Seagulls**
This little study took five minutes. I began with the central gull and the chimney pot. I put in the chimney, leaving a tiny gap so paint did not run through the entire shape. Next I painted the second chimney, then the right-hand gull and the roof.

Always finish painting an entire object before moving on to the next – it will help you to judge the proportions correctly.

▶ **Camels**
These camels are in fact two shapes linked together by their shadows, resulting in just one final shape. I began with the camels then, keeping the shapes nice and wet, I began painting the long shadows formed by the legs.

Simplifying the subject

If a subject is quite complex, direct painting is a wonderful way of keeping it simple. Imagine building up a series of puzzle shapes, one shape leading logically onto the adjoining one as the whole picture evolves. Although direct painting lends itself to quick studies, it is also an ideal method for more finished paintings.

▶ Martin and Emma
I linked the two children together but did not allow the sections to run. I particularly like their shoes and socks – the shapes are all clean and accurate, but their white socks are suggested by the pattern. This study took me just over 10 minutes.

▼ Hedgerow Daisies
10.5 × 8.5 cm (4¼ × 3½ in)
I put in the positive shapes first, then the background. It was important that the positive areas were still wet so that they could bleed into the background and create softer, more suggestive areas.

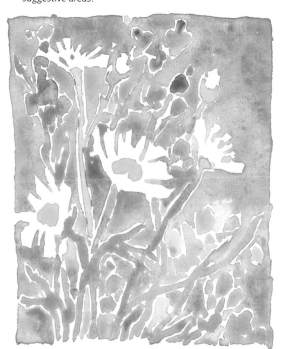

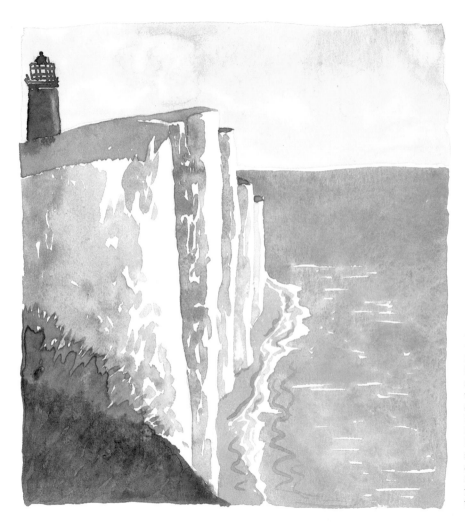

■ QUICK TIP

Remember to leave some unpainted areas of paper in your pictures; this will create an impression of light as well as stronger contrasts.

◀ **Walking the Cliffs**
16.5 × 15 cm (6¼ × 6 in)
Painting directly kept the stunning sharpness of the view on a hot, still day and retained the luminosity of the light at the coast. I kept all the shapes separate, only allowing the paint to run so that it linked the lighthouse to the land.

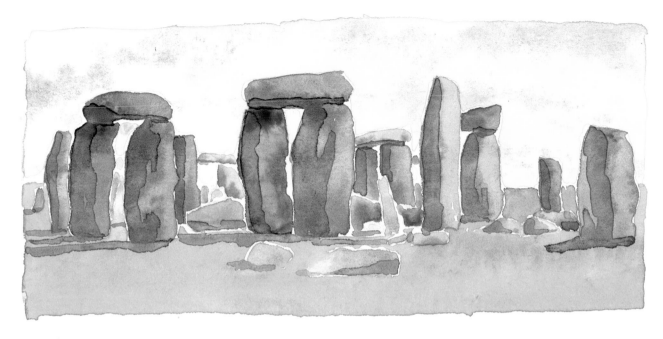

▲ **Stonehenge**
8 × 18 cm (3¼ × 7 in)
I began with the stones, dropping in the darks as I went along, then added the grass as one section and tackled the sky as a large wet-in-wet shape, dropping in the blue. Lastly the shadows were added once the grass was dry.

Tonal values
Remember to check the tonal values as you paint. You can add shadows on top when the first layer of paint is dry but if an entire shape is too light it is always noticeable if a layer of paint is added later. If the area is too dark and you make an attempt to lift some pigment once it is dry, this too will be obvious.

│ QUICK TIP

If you leave a space this should be intended only for a white object or a light area, not to paint something in later.

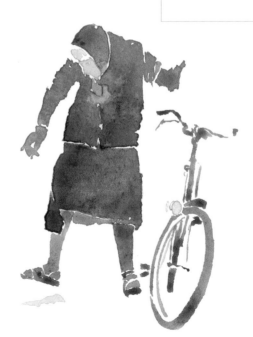

▲ **Happy With Mum**
This mother and child study took just under 10 minutes. It was the bright clothes of the child against the darker clothes of the mother that attracted me to the subject. The bench had to be included to make sense of the figures, but there was no need to paint all of it.

◄ **Icy Morning**
A No. 10 round brush is perfect for painting things such as this bike where the brush strokes need to be very simple but accurate. Painting directly onto the paper in this way results in a fresh, uncluttered image that avoids detail.

Direct painting

Direct painting can be an exciting way of quickly interpreting a complex subject by concentrating on just shape and colour and looking at it as a jigsaw puzzle – a collection of small individual shapes that all lock together to form a whole.

Preparing to start

For your subject, choose something complex such as a vase of flowers or a collection of items on a windowsill. Get your paper and paints ready, but before starting to work just sit and take a really good look at your subject. Close one eye so you can see the blocks of colour and tone more clearly then, holding a pencil at arm's length, imagine there is a sheet of glass in front of you and begin to draw around the shapes that you see onto this imaginary sheet. This will focus your eye on the shapes you are going to paint.

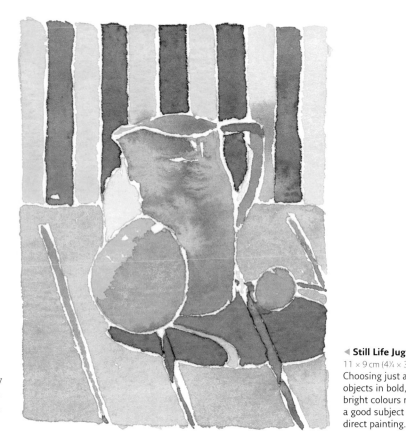

◀ **Still Life Jug**
11 × 9 cm (4¼ × 3½ in)
Choosing just a few objects in bold, bright colours makes a good subject for direct painting.

Putting paint to paper

You can start anywhere, but it is often advisable to start at or near the middle. Using a No. 10 round brush, paint your first shape. This is really important, as it sets the scale of your painting: if you make the shape too big you won't get your entire subject on the page, while if you paint it too small, you will end up with a tiny picture.

Looking carefully at the adjoining shape, mix your colour and paint it in, leaving a tiny white gap of dry paper so that it doesn't run into the first. If you feel you want to adjust the first shape, don't! Just work from shape to shape without altering your previous sections.

If one shape does bleed into the adjoining shape, don't try to mop it up – just allow the paint to run and move onto the next shape. As you gradually build up the picture in this logical way you will find that you cease to look at it as a subject but become fascinated instead by the shapes and their relationship with each other.

Points to remember

■ Take time to plan your composition before you begin.

■ If you touch a wet shape and the colours run, don't attempt to blot it.

■ Create an outer edge to your painting by consciously deciding where to finish.

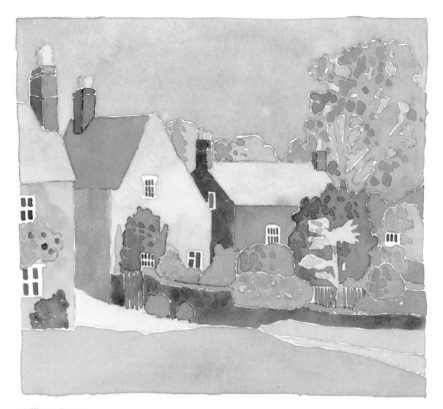

▲ **Village Green**
16 × 18 cm (6¼ × 7 in)
Buildings become much easier to analyse when you look at their geometric shapes and ignore details.

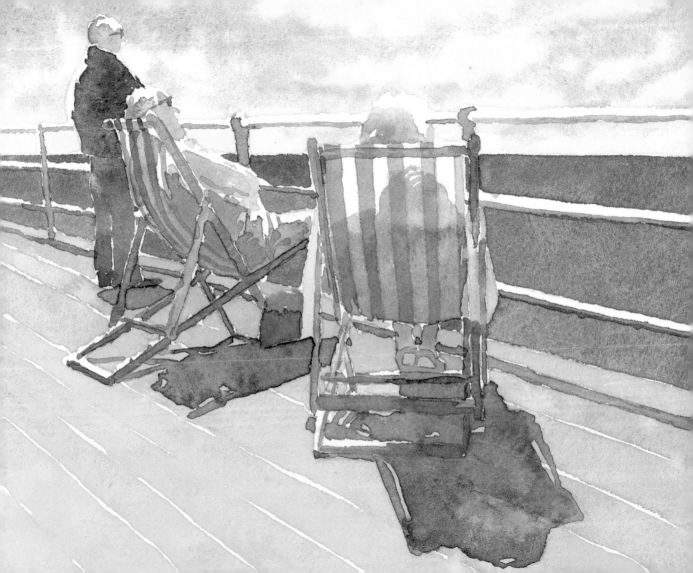

CHOOSING A SUBJECT

Deciding what to paint is a very personal thing. The approach that you take to your subject is what matters – whether it is a busy boatyard scene or a single flower, it can be as complex or as simple as you choose to make it.

In order to make your paintings interesting to the viewer, try to choose viewpoints that are a little out of the ordinary; when you are painting a well-known object or view, for example, look for an alternative perspective. This chapter contains a selection of ideas for some 30-minute paintings to set you on the road.

◀ **Channel Crossing**
15 × 20 cm (6 × 8 in)
The quiet atmosphere of this painting suggests that there is time for personal contemplation on this shared journey.

Keeping your pictures simple

Limiting your subject to what attracted you to it in the first place is most important in order to avoid a cluttered composition that will confuse the viewer's eye. If there are a number of areas that interest you in a subject, rather than grouping them together consider painting them as individual studies to keep your work as simple as possible.

Choose everyday objects that are readily available rather than spend time searching for a perfect set-up to paint. Look for items that have an interesting shape, such as a jug or teapot with an attractive handle, a jar of jam with a spoon in it or an egg in a pretty eggcup.

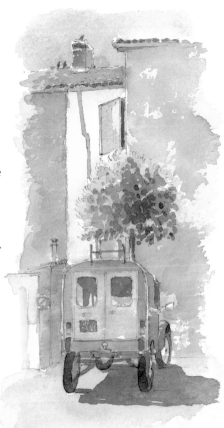

◄ **Little Blue Car**
21 × 11 cm (8¼ × 4½ in)
This little car needed to be placed in its surroundings as I wanted to show it was a hot day. The shadow was dark and the square was deserted save for the birds on the rooftops. The windows were all hidden behind shutters to keep the heat at bay.

▲ **Washing Day**
9 × 8 cm (3½ × 3 in)
I saw this washing blowing in the breeze and liked the contrast of it against the dark wooden arched gates. Had it been set against a brick wall, I doubt it would have caught my interest as much.

Avoiding detail

If you paint a small subject such as a doorway or a window with shutters, the texture of the wood grain or flaking paintwork may not be necessary to enhance your picture – the tonal contrasts and colour can suggest more to the viewer. Adding a lot of detail such as bricks and tiles may result in an overworked finish, so leave them for the viewer's imagination to fill in.

◄ **Beach Memories**
The hat and shoes seemed to go nicely with the basket, but when I put them all together the group looked contrived. Treated individually, they maintain their own interest but remain linked.

▲ **Matches**
Most people have matches in the house, and they make a quick, fun picture that needn't take long to paint.

Still life

When you think of still life subjects you probably visualize items such as pots, jugs and flowers perhaps arranged with a draped cloth. However, sometimes you may not have time to set up an arrangement, or indeed you may spend so much time choosing items that go well together and placing them in a perfect composition that by the time you are ready to paint you've run out of the time or the desire to do so.

Choosing something simple to paint that doesn't involve setting anything up can be very rewarding. It is sometimes better to seize the moment and just paint almost anything!

◀ **Buttons**
If you have a button box, consider selecting a few brightly coloured buttons as a subject.

▲ **A Bowl of Lemons**
The yellow of the lemons against the blue bowl made a perfect little subject to paint.

▼ **Bakery Treat**
Choosing a number
of items on the same
theme allows you to
explore a series.

Arranging your items

Make sure the objects you are going to
paint are in good directional light.
Emphasize the light on them and include
the shadows they cast in order to place
them on a surface.

 If you group items together, make
sure they are simple shapes and avoid
becoming bogged down with details.
A single item can sometimes have just
as much impact, but needs to be
interesting in its own right.

Painting on a small scale

One of the trickiest aspects of painting is choosing and simplifying what you are going to paint. Your aim here is to create a small picture, avoiding too much peripheral detail. This will help you to focus and avoid unnecessarily extending your subject matter.

Finding a subject

Your subject could be a building, a garden, a street scene and so forth. When you have found something you want to paint, consider what it was that initially attracted you to it. It's easy to get carried away by what is around your subject and before you know it, you may find you are trying to paint the entire building or indeed street!

Look at your chosen subject and imagine you are going to use a zoom lens

to select just part of it – a window, doorway or archway in a building, for example. Ask yourself how much is necessary to make your painting work.

Eliminating detail

Once you have chosen what to paint, look carefully at what you really need to include. Keep your painting relatively small, no bigger than postcard size, and just make a simple line drawing, avoiding too much detail. Work with your round brush and use your rigger only for dropping in colours.

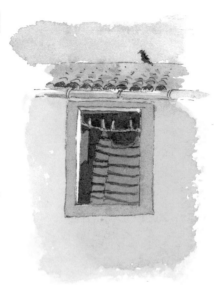

◀ **Drying the Washing**
I liked the contrast and shapes of the pegs against the dark interior and while I was painting this a bird landed on the roof and made the picture.

▼ **Window Box**
There was nothing visible through this window but the bright flowers outside contrasted beautifully, making it a very appealing subject for an artist.

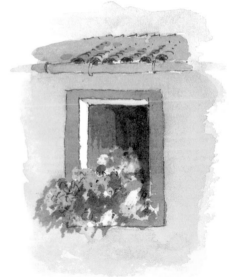

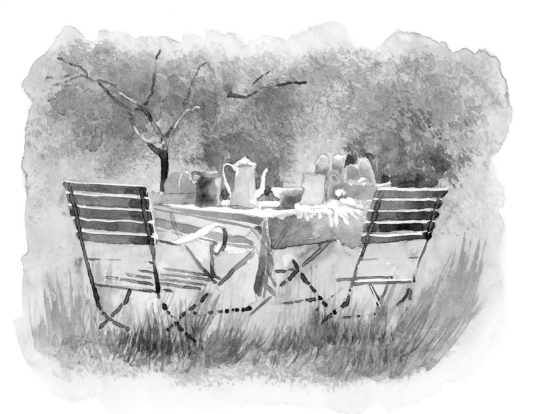

◀ **Lunch in the Garden**

16 × 22 cm (6½ × 8½ in)

I wanted to emphasize the sunlight on the table outdoors. To do this I needed to include some background foliage and also the chairs, otherwise the painting could have appeared to be a still life indoors.

The two paintings of windows shown on the opposite page are a good example of simplifying the subject and not tackling too much. By focusing on the point of interest all the peripheral information is avoided, making for a more succinct picture.

Points to remember

▪ Focus in on your chosen subject as if you were looking through a zoom lens.

▪ Concentrate on the subject rather than on small details.

▪ Keep your painting simple by using the round brush and a small scale.

Boats

Boats are a popular subject for artists, and on the coast you shouldn't have much trouble finding a boatyard or harbour where you can sketch, paint or take photographs.

Trying to select something from a mass of detail such as you may find in a busy boatyard may seem overwhelming. If you find just one item that you like, ignore everything else around it and focus on it exclusively.

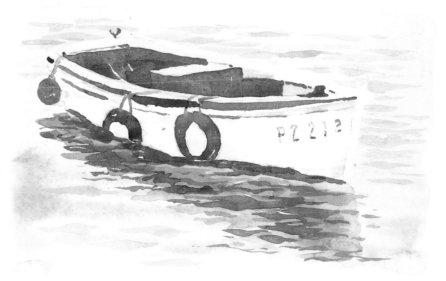

▲ **Mousehole**
11 × 17 cm (4½ × 6¾ in)
The light on the water and the bright reflections of the boat were what drew me to this subject. I used bold shapes of colour for the boat and directional brush strokes to suggest water.

◀ **Tied Up**
A subject can be as simple as this rowing boat, selected from hundreds of others.

◀ **Cleaning the Hull**
This boat was among a clutter of oil barrels, metal piping and all sorts of junk. All I was interested in was the wonderful shape of the hull on the scaffolding. The negative spaces were very appealing and I treated the entire subject as just one shape.

▲ **Covered for Winter**
No one was about, the weather was cool and a bit blustery, and the boats looked as if they were abandoned until the coming of better weather. I liked the bright covers on the boats, all parcelled up against the locked boathouse.

Water

Water has so many moods that it always makes a challenging subject. The key to success is usually to put less paint on the paper rather than overwork it. Using transparent pigments and avoiding too many layers of watercolour will also help to create the illusion of water and avoid a heavy or muddy-looking finish.

There is often a sparkle of light on the surface which can be suggested by painting on the paper when it is dry, using strong tonal contrasts and leaving at least a little of the white paper showing.

▶ **Sailing off the Greek Isles**
19 × 19 cm (7½ × 7½ in)
Here my aim was to make an atmospheric picture rather than painting a simple view, so I emphasized the colours and textures and kept the composition relatively simple.

▼ **Winter Trees**
16 × 15 cm (6½ × 5½ in)
The reflections made by the bare branches of winter trees led to this almost abstract painting. I mainly used my round brush, but all the tiny swirls in the rippling water were created using my rigger brush and a more dilute colour.

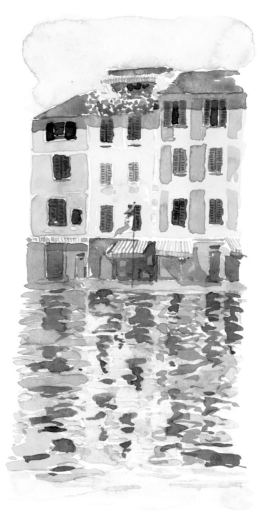

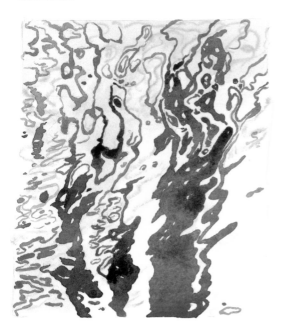

◄ **Portofino Reflections**
23 × 11 cm (9 × 4½ in)
We tend to think of water as being blue, but sometimes it is a mass of fabulous colours. For this painting I dipped my round brush into the brightest colours, blocking in the buildings and tackling the reflections all in one go with the pressure line stroke.

Flowers

Choosing a particular technique for the type of flowers you are going to paint can have an enormous impact on the finished result. The same subject painted wet-in-wet can look very different from how it appears when defined brush strokes have been used.

If you are painting in the garden on a warm, breezy day a larger wet-in-wet painting may be possible in 30 minutes, with final details added when the initial washes have dried. Wet-in-wet within shapes is also good outdoors and is particularly suited to complex shapes rather than the larger, looser techniques, which suit bigger and bolder subjects.

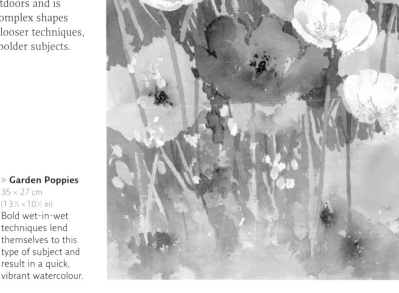

▶ **Garden Poppies**
35 × 27 cm
(13¾ × 10½ in)
Bold wet-in-wet techniques lend themselves to this type of subject and result in a quick, vibrant watercolour.

▼ Jar of Buttercups
25 × 23 cm (10 × 9 in)
I felt that buttercups
in a jam jar needed
a loose technique,
probably because
they are a natural
little wild flower
placed in the most
unsophisticated
container possible.

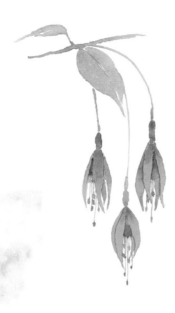

◄ Fuchsia Study
This delicate little
fuchsia was painted
with simple pressure
line brush strokes.

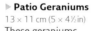

► Patio Geraniums
13 × 11 cm (5 × 4½ in)
These geraniums
were on a very hot
patio in France. I
chose bright blue for
the background to
give the impression
of a deep blue sky
rather than the grey
stone of the patio
behind them.

Using white space

White objects are traditionally left unpainted in watercolour save for their shadows. Diluting some of the dark colours surrounding them will make the white shapes become more a part of the picture rather than starkly contrasting spaces left on the paper.

MATERIALS USED
2B pencil
No. 10 round brush
Saunders Waterford
 380 gsm (200 lb)
 Not paper
Cadmium Yellow
Cadmium Orange
Indigo
Midnight Green
Sunlit Green

1 Draw the flowers and leaves. Using the tip of the brush and Cadmium Yellow, paint the flower centres then, while still wet, drop some Cadmium Orange where the petals join the centres. Load the brush with Sunlit Green and paint the stalks and leaves, keeping them loose.

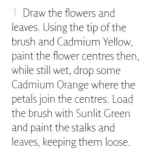

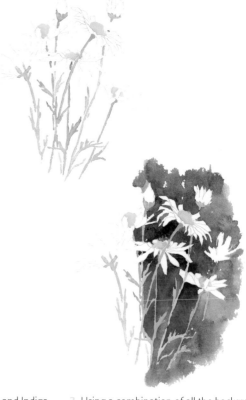

2 Using a mix of Midnight Green and Indigo, begin the background at the top of a daisy. To create a lacy edge, drag the brush across the paper using the dry brush stroke. If the centre is still damp some colour will run into the green, linking the flower and background.

3 Using a combination of all the background colours, continue to work round, merging the wet outer edges. There should be no hard edges within the darks. Change the colour mix as you go to create a varied background, dropping in the different colours.

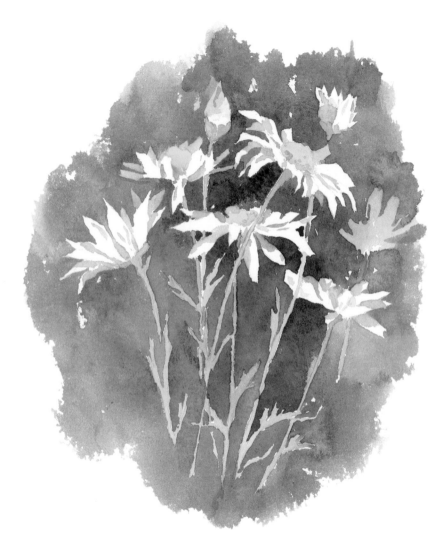

4 Using very dilute Indigo and Midnight Green, cover any daisy shapes you avoided within the background wash to keep these flowers as part of the background. Apply subtle brush strokes to separate the petals on the main daisies, using the pressure line brush stroke. With the tip of the brush, add little blobs of Cadmium Orange to the centres.

◀ **Spring Daisies**
22 × 16 cm (8¾ × 6¼ in)

Landscapes

Painting direct is a wonderful way of painting a landscape, especially on location. It stops the desire to fiddle and helps you to concentrate on the main elements within the composition.

It is easy to get carried away and try to include things outside the natural field of view. If you have to move your head from side to side or up and down to see all of your subject, you are trying to encompass too much within your composition. Move further back from your subject or select a smaller part of it for your painting.

▼ **Lavender and Poplars**
10 × 26 cm (4 × 10⅓ in)
Using just my round brush, I needed less than 10 minutes to complete this little picture. I began with the building and tall poplars, then painted the foreground lavender and finally the distant hills. I like the shape created by leaving the sky unpainted.

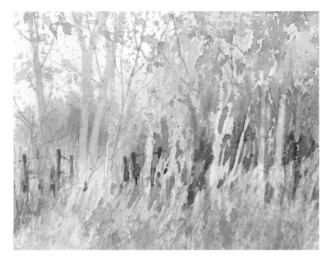

▲ **Forgotten Walk**
16 × 27 cm (6¼ × 10½ in)
This painting was all done in one stage. I put in the initial colours wet-in-wet, then moved them about with my fingernail to create some lighter grass areas. As the paint dried, I dropped in darker areas with my rigger. I used the hake for the leaves and the rigger for the final details.

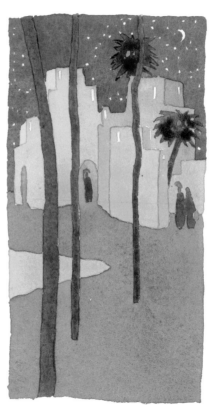

◄ **Oasis**
17 × 9 cm (7 × 3⅓ in)
I painted this from my imagination, more as a pattern than a traditional landscape. It was the shapes that interested me and the strong design element that arose from using these colours.

People

Figures can seem daunting, but tackling them as basic shapes rather than thinking of them as people in all their complexity makes it easier to simplify them. There is no need to describe them carefully as the viewer's eye will fill in what you leave unsaid.

Photographs are a great way of capturing the moment and can be very useful for reference. However, painting from a photograph tempts you to add too many fussy details, so where it is feasible to do so it is best to make sketches or paint on location.

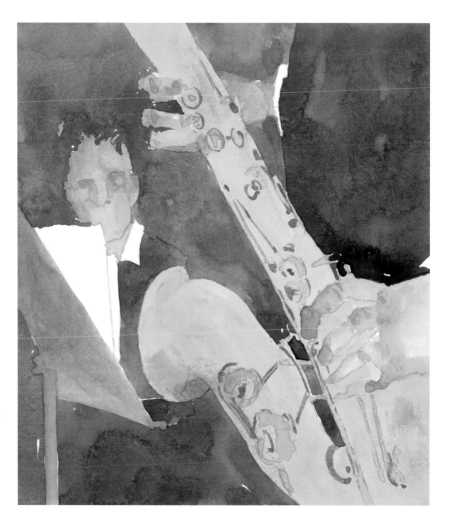

▶ **Saxophone at Summersaults**
22 × 19 cm (8½ × 7½ in)
I sometimes go to a local jazz café and sketch or paint the musicians. The tables are all packed together so I sit fairly close to the figures, which makes close-ups inevitable. The picture is almost chosen for me depending on where I can sit.

QUICK TIP

Whether you are painting a pair of figures or a small group, linking them together increases their intimacy while leaving spaces between them isolates them.

◄ **Weekend Away**
I used a photograph as reference for this painting and felt that it resulted in a more detailed finish than I wished for.

▲ **Making Friends**
From a vantage point on the promenade, I watched a large group of students sitting on the pebble beach below. The shapes of all the linked figures made a natural subject. I chose to paint just three of them.

Animals

When you are painting animals, rather than becoming bogged down in detail your best plan is to look for the shapes they create either as silhouettes or the patterns made by their markings.

Take particular notice of the negative spaces on the page that are created by an animal's body and drop in colour changes to emphasize its form. This gives an overall impression of an animal which is often more successful than a painting that has been laboured over to add lots of information.

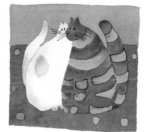

◀ **Best Friends**
13 × 13 cm (5 × 5 in)
This picture has a strong design element to it; I was mainly interested in the shapes and patterns within it.

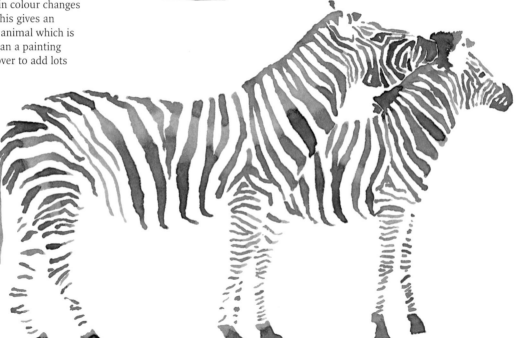

▶ **Camouflaged Together**
These zebras were a real puzzle to paint. I used just two colours and concentrated on fitting the shapes together, thinking of the white stripes as if they were negative spaces as I worked from one shape to the next.

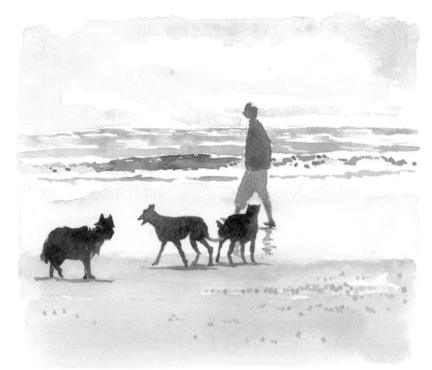

◀ **Cautious Encounter**
16 × 19 cm (6½ × 7½ in)
Despite this being a fairly compact picture it portrays a sense of space. There's a feeling that the viewer is on a large expanse of beach and is looking at just a tiny section of it. I liked the narrative element of the dogs' interaction while the owner looked out to sea, engrossed in his own world.

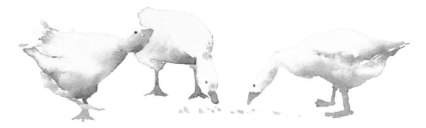

▶ **Three's a Crowd**
These geese were so aggressive I had to take photographs rather than painting them on the spot. I painted them wet-in-wet, tackling each individually and dropping in the darker shadows as I went along.

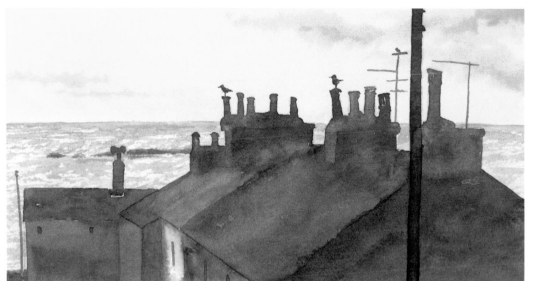

◀ **Chimney Pots**
12 × 24 cm (4 ½ × 9 ½ in)
The strong contrasts in this subject pleased me, as did the shapes of the chimneys against the sky. The evening light just caught a small section of building; the rest was all in shadow.

▼ **Beach Huts**
The bright colours, simple shapes and strong shadows of these beach huts on a sunny day made them a very appealing subject for a quick and lively painting.

Buildings

Buildings are always interesting to paint. In narrow streets the view ahead can often be inspiring, but consider different viewpoints. Look up at the tops of the buildings and the shapes they make against the skyline or other buildings.

The light is important; strong shadows can pick out details such as raised stonework, recesses or structural details. This emphasizes the perspective, creating a more three-dimensional result.

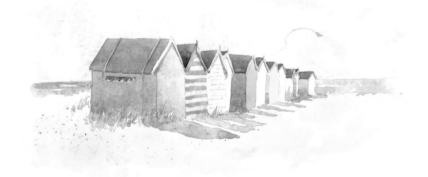

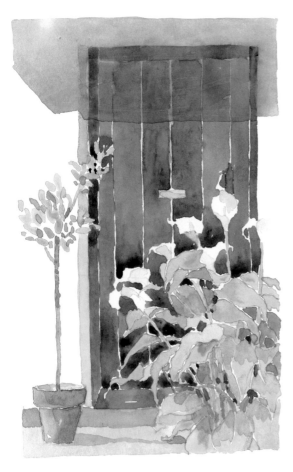

◀ **The Green Door**
20 × 13 cm (8 × 5 in)
I worked quickly from one shape to the next and as it was a hot day the paint dried almost as it touched the paper, so none of the shapes ran into each other. I began with the lilies, then the pot, and finally slotted in the door.

▶ **Terraced Cottage**
9 × 6 cm (3½ × 2½ in)
Knowing where to stop is important in a painting. There is no need to paint up to the edge of a building; in fact, working up to an edge like this leaves something to the imagination.

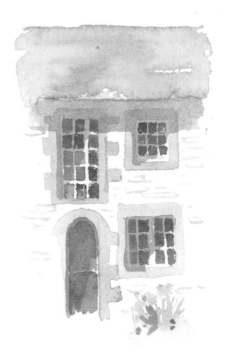

Conclusion

I hope the various subjects I have chosen will inspire you to paint something you have not considered in the past, or to work in a way you haven't tried before. Almost anything can make a good subject provided you keep it simple and enjoy letting the watercolours work for you.

FURTHER INFORMATION

Here are some organizations or resources that you might find useful to help you to develop your painting.

Art Magazines
The Artist, Caxton House, 63/65 High Street, Tenterden, Kent TN30 6BD; tel: 01580 763673 www.theartistmagazine.co.uk
Artists & Illustrators, 26-30 Old Church Street, London SW3 5BY; tel: 020 7349 3150 www.aimag.co.uk
International Artist, P. O. Box 4316, Braintree, Essex CM7 4QZ; tel: 01371 811345 www.artinthemaking.com
Leisure Painter, Caxton House, 63/65 High Street, Tenterden, Kent TN30 6BD; tel: 01580 763315 www.leisurepainter.co.uk

Art Materials
Daler-Rowney Ltd, P. O. Box 10, Bracknell, Berkshire RG12 8ST; tel: 01344 461000 www.daler-rowney.com

T. N. Lawrence & Son Ltd, 208 Portland Road, Hove, West Sussex BN3 5QT; tel: 0845 644 3232 or 01273 260260 www.lawrence.co.uk
Winsor & Newton, Whitefriars Avenue, Wealdstone, Harrow, Middlesex HA3 5RH; tel: 020 8427 4343 www.winsornewton.com

Art Shows
Affordable Art Fair, The Affordable Art Fair Ltd, Unit 3 Heathmans Road, London SW6 4TJ; tel: 020 7371 8787 www.affordableartfair.co.uk
Art in Action, Waterperry House, Waterperry, Nr Wheatley, Oxfordshire OX33 1JZ; tel: 020 7381 3192 (for information) www.artinaction.org.uk
Patchings Art, Craft & Design Festival, Patchings Art Centre, Patchings Farm, Oxton Road, Calverton, Nottinghamshire NG14 6NU; tel: 0115 965 3479 www.patchingsartcentre.co.uk

Art Societies
Royal Institute of Painters in Water Colours, Mall Galleries, 17 Carlton House Terrace, London SW1Y 5BD; tel: 020 7930 6844 www.mallgalleries.org.uk
Society for All Artists (SAA), P. O. Box 50, Newark, Nottinghamshire NG23 5GY; tel: 01949 844050 www.saa.co.uk

Bookclubs for Artists
Artists' Choice, P. O. Box 3, Huntingdon, Cambridgeshire PE28 0QX; tel: 01832 710201 www.artists-choice.co.uk
Painting for Pleasure, Brunel House, Newton Abbot, Devon TQ12 4BR; tel: 0870 44221223 www.readersunion.co.uk

Internet Resources
Art Museum Network: the official website of the world's leading art museums www.amn.org
Artcourses: an easy way to find part-time classes, workshops and painting holidays in Britain and Europe www.artcourses.co.uk

The Arts Guild: on-line bookclub
www.artsguild.co.uk
British Arts: useful resource to help you
to find information about all art-related
matters
www.britisharts.co.uk
British Library Net: comprehensive A-Z
resource including 24-hour virtual
museum/gallery
www.britishlibrary.net/museums.html
Fiona Peart: the author's website, with
details of her workshops, DVDs, and
a gallery of her paintings
www.fionapeart.com
Galleries: the UK's largest-circulating
monthly art listings magazine, with details
of exhibitions and other art services
www.artefact.co.uk
Galleryonthenet: provides member artists
with gallery space on the internet
www.galleryonthenet.org.uk
Jackson's Art Supplies: on-line store and
mail order company for art materials
www.jacksonsart.com
Open College of the Arts: an open-access
college, offering home-study courses to
students worldwide
www.oca-uk.com

Painters Online: interactive art club run
by The Artist's Publishing Company
www.painters-online.com
WWW Virtual Library: extensive
information on galleries worldwide
www.comlab.ox.ac.uk/archive/other/
museums/galleries.html

Videos
APV Films, 6 Alexandra Square,
Chipping Norton, Oxfordshire OX7 5HL;
tel: 01608 641798
www.apvfilms.com
Teaching Art, P. O. Box 50, Newark,
Nottinghamshire NG23 5GY;
tel: 01949 844050
www.teachingart.com

FURTHER READING
Why not have a look at other art
instruction titles from Collins?

Bellamy, David, *Learn to Paint Watercolour
 Landscapes*
 Painting Wild Landscapes in Watercolour
Blockley, Ann, *Learn to Paint Country
 Flowers in Watercolour*
 Watercolour Textures

Crawshaw, Alwyn, *Alwyn Crawshaw's
 Ultimate Painting Course*
 Learn to Paint Watercolours
Crawshaw, Alwyn, Crawshaw, June and
 Waugh, Trevor, *Need to Know?
 Watercolour*
Harrison, Don, *Don Harrison's Top
 Watercolour Techniques*
Jennings, Simon, *Collins Artist's Colour
 Manual*
 Collins Complete Artist's Manual
King, Ian, *Gem Watercolour Tips*
Shepherd, David, *Painting with David
 Shepherd*
Simmonds, Jackie, *Gem Sketching*
Soan, Hazel, *Gem 10-minute Watercolours*
 Learn to Paint Vibrant Watercolours
 Secrets of Watercolour Success
Trevena, Shirley, *Vibrant Watercolours*
Waugh, Trevor, *Winning with Watercolour*
Whitton, Judi, *Loosen up your Watercolours*

For further information about Collins
books visit our website:
www.collins.co.uk

INDEX